GLEN BAXTER
HIS LIFE

GLEN BAXTER
HIS LIFE

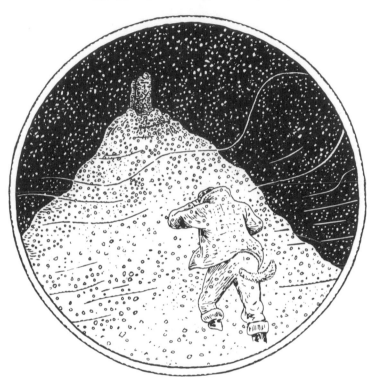

The Years
of Struggle

THAMES AND HUDSON

FOR Z&H

Printed and bound in Hungary.

CONTENTS

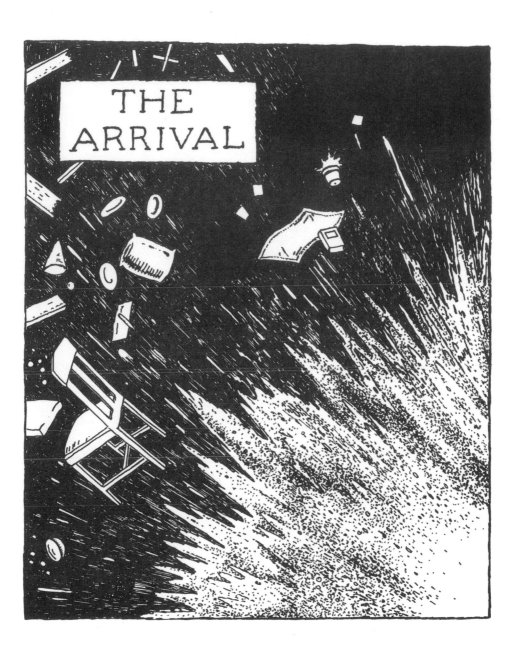

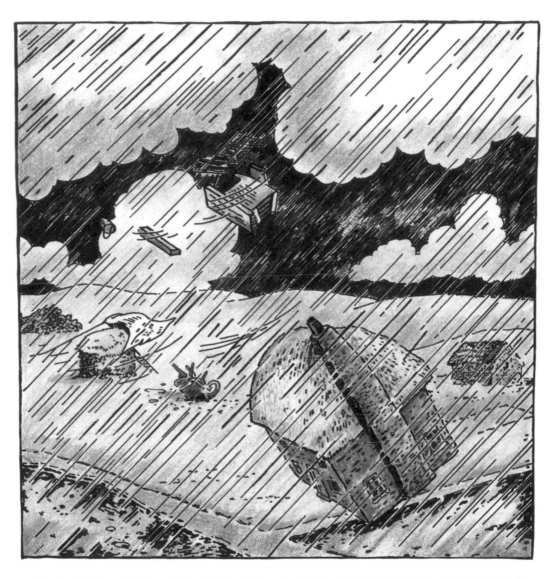

IT WAS ONE OF THOSE LONG ENGLISH SUMMER
DAYS THAT SEEM TO GO ON FOR EVER...

ACCORDING TO THE OFFICIAL RECORDS I WAS
BORN AT PRECISELY 10.19 ON THURSDAY, MAY
16TH.....

HOWEVER, THERE SEEMED TO BE SOME CONFUSION
SURROUNDING THIS MOMENTOUS EVENT...

IN LATER YEARS MY MOTHER WAS ABLE
TO FURNISH ME WITH PRECISE DETAILS
OF MY ARRIVAL

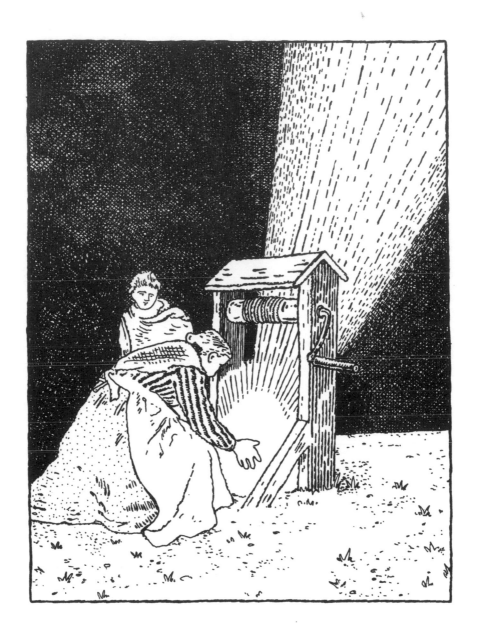

....WHILST MY FATHER WOULD OFTEN RECOUNT HIS VERSION OF THE TRAUMATIC EVENT....

SUFFICE IT TO SAY I WAS A STURDY CHILD

FATHER HAD MANAGED TO SAVE A LITTLE
MONEY AND SO WE LEFT OUR RATHER
CRAMPED BASEMENT ROOM AND MOVED
ACROSS THE VALLEY INTO MORE SPACIOUS
ACCOMMODATION

I SPENT THE FIRST FOUR YEARS OF MY CHILDHOOD HAPPILY ROMPING ROUND OUR LITTLE YORKSHIRE HOME...

OUR NEW HOME WAS CERTAINLY AN IMPROVEMENT ON OUR PREVIOUS ABODE, ALTHOUGH THERE WERE, AT FIRST, A FEW MINOR PLUMBING PROBLEMS

MY SISTER AND I TOOK TURNS WITH
THE HOUSEHOLD CHORES

IT WAS MY SISTER'S DUTY
TO ASSIST MY FATHER WITH
HIS DANDRUFF PROBLEM

WHILST I WAS SET THE TASK OF
TIDYING THE KITCHEN

ON SUNDAYS IT WAS MY JOB
TO PREPARE A PICNIC LUNCH
USING MOTHER'S HOME-BAKED
WHOLEMEAL BREAD....

IT WAS ABOUT THIS TIME THAT I
BEGAN TO TAKE AN INTEREST IN
COOKERY. MANY WERE THE TIMES
THAT OUR LITTLE HOUSE RESOUNDED
TO THE SOUNDS OF MY OMELETTE —
MAKING.....

MY SISTER HAD BEGUN TO DEVELOP
SOME DISTRESSING HABITS

THROUGHOUT CHILDHOOD, THE CONSTANT
SPECTRE OF FAMILY RUIN DOGGED OUR
EVERY MOVEMENT. WE WERE LECTURED
ON THE IMPORTANCE OF CLEAN UNDER-
WEAR, ESPECIALLY WHEN CROSSING
BUSY ROADS. THERE SEEMED TO BE
SOME MYSTERIOUS CONNECTION
BETWEEN PERSONAL HYGIENE AND
TRAFFIC FLOW. I NEVER DID QUITE
UNDERSTAND THIS, BUT FOR YEARS
I HAD RECURRING DREAMS, RIDDLED
WITH FEAR AND GUILT, IN WHICH
MY PARENTS WOULD OPEN THE
LOCAL NEWSPAPER...

WHENEVER WE STAYED OUT LATE,
MOTHER WOULD INVARIABLY BE
WAITING UP FOR US ON OUR RETURN

WINTERS WERE ESPECIALLY HARSH
—ON THE 15TH OF JANUARY, FATHER
UNVEILED HIS NEW SCHEME OF
SWEEPING ECONOMIC MEASURES

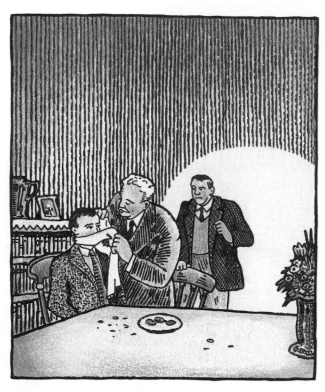

IT WAS A BOLD PLAN TO CUT
DOWN ON FOOD BILLS

AS I REMEMBER, THERE WAS
ALWAYS A RUSH TO BE THE
FIRST TO OPEN THE PRESENTS
ON CHRISTMAS MORNING

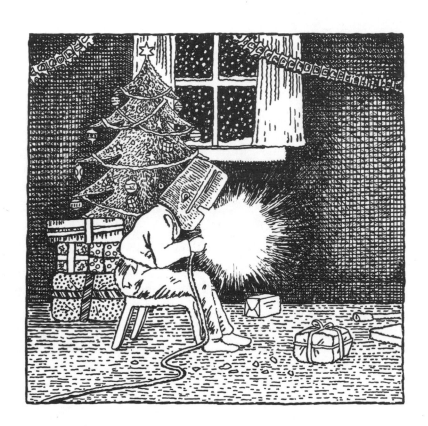

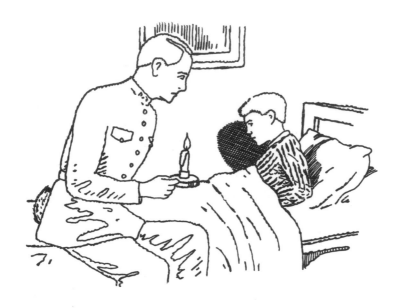

MY SISTER AND I SOON MADE FRIENDS WITH THE
LOCAL POLICEMAN. THE YOUNG CONSTABLE SEEMED
TO ENJOY MY COMPANY. I REMEMBER ONE NIGHT
HE CAME UP TO SEE ME IN MY BEDROOM.
"I'VE SOMETHING TO SHOW YOU...." HE BLURTED,
SOMEWHAT EXCITEDLY.

I DRESSED QUICKLY AND FOLLOWED HIM
DOWNSTAIRS. HE LED ME OUT INTO THE
GARDEN AND PAUSED BRIEFLY BY THE GATE.

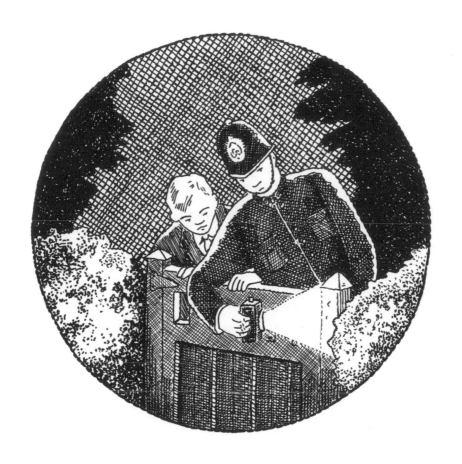

"THIS IS WHERE I KEEP MY CHEWING
GUM, YOUNG LAD" HE CONFIDED

OUR STANDARD OF LIVING WAS
SOON TO BE INCREASED BEYOND
MY WILDEST DREAMS

NEWS OF FATHER'S PROMOTION
AT WORK FINALLY CAME THROUGH

AT LAST I WAS TO HAVE MY
OWN BEDROOM

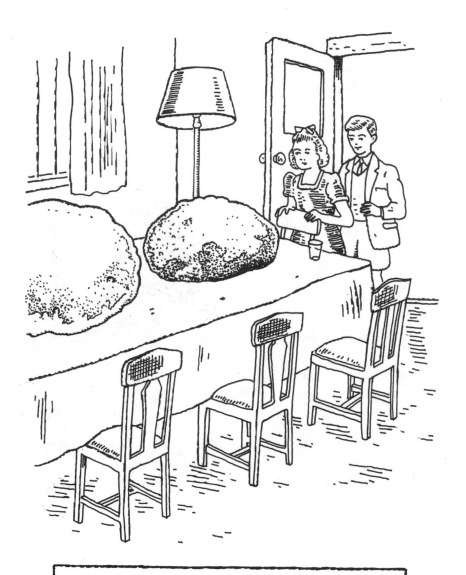

FROM THAT DAY ON, BOTH MY
SISTER AND 1 WERE GRANTED
PERMISSION TO HAVE OUR
SUET ALLOWANCE DOUBLED

ON SPECIAL OCCASIONS THE FAMILY WENT
OUT TO RESTAURANTS

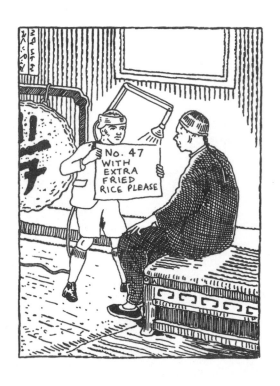

FATHER WOULD OFTEN SEND ME
TO ATTRACT THE ATTENTION
OF THE WAITER

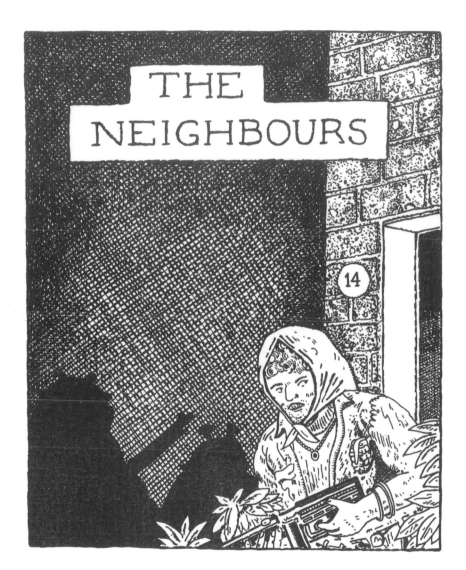

AT NUMBER 56 LIVED MR. COSGROVE.
HE HAD MOVED UP HERE FROM
"SOMEWHERE DOWN SOUTH", AND
SUBSEQUENTLY WAS NEVER ACCEPTED
BY THE DENIZENS OF IVERIDGE
TERRACE. MOTHER WARNED US ABOUT
HIM AND INTIMATED THAT HE WAS
SUFFERING FROM SOMETHING CALLED
"DELUSIONS OF GRANDEUR"......

WE SOON CAME TO KNOW
THE ALCOTT BROTHERS

THERE WAS YOUNG ALAN....

WHO DEVOTED HIS SPARE TIME ALMOST
EXCLUSIVELY TO THE GNAWING OF TWINE

AND, OF COURSE, ALISTAIR

.... THE ETYMOLOGIST

THE HOUSE OPPOSITE WAS OCCUPIED
BY OLD MR. WHORPESTEAD

IT WAS KNOWN HE HAD BEEN REFUSING
ANTIBIOTICS FOR SOME TIME

THEN THERE WAS OLD MRS. SNEDLEY.
WE SAW VERY LITTLE OF HER AS SHE
SPENT MOST OF HER TIME INDOORS
CATALOGUING HER COLLECTION OF
EARTHWORMS

AT NUMBER 102ᴬ LIVED MR F.X BLEAMSWORTH. FOR YEARS IT HAD BEEN ASSUMED THAT HE WORKED IN A BANK NEAR ROTHWELL...

... BUT SINCE THE GRISLY AFFAIR OF THE DESECRATED PELMET, A FEELING OF UNEASE HAD SETTLED UPON THE DENIZENS OF IVERIDGE TERRACE. THERE WERE SOME FOLK WHO HAD OTHER IDEAS ABOUT THE REAL NATURE OF MR. B'S CALLING.

EVERY YEAR THE FAMILY WENT
TO THE SAME LITTLE CHALET ON
THE OUTSKIRTS OF MORECAMBE

MANY WERE THE HAPPY HOURS SPENT
THERE. MY SISTER AND 1 WOULD PLAY
"HUNT THE HOT-WATER BOTTLE",
"BURYING THE THERMOS" AND "PUMMEL
THE BRACKEN."

OCCASIONALLY A SPECIAL OUTING WAS
ARRANGED. THIS COULD BE ANYTHING
FROM A RAMBLE IN SHACKLETON'S
WOODS TO A VISIT TO THE LOCAL QUARRY.
FATHER WOULD SPEND MANY HOURS
CHOOSING THE EXACT SPOT WHERE
TO PLACE THE PICNIC BASKET

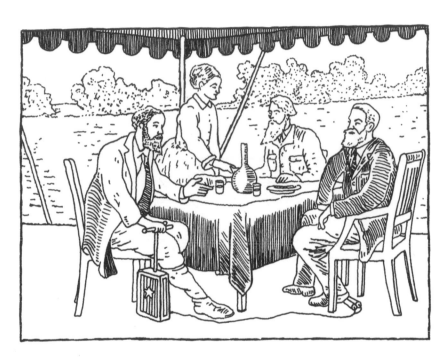

THERE WERE, OF COURSE, THE USUAL
MINOR FAMILY DISAGREEMENTS

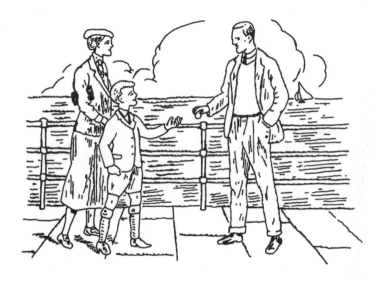

IF WE WERE EXCEPTIONALLY GOOD,
FATHER WOULD ALLOW US TO TOUCH
THE POLISHED PENNY HE ALWAYS
CARRIED IN HIS POCKET

FATHER WAS NOTED FOR HIS FASTIDIOUS
PREPARATIONS OF SUNDAY LUNCH

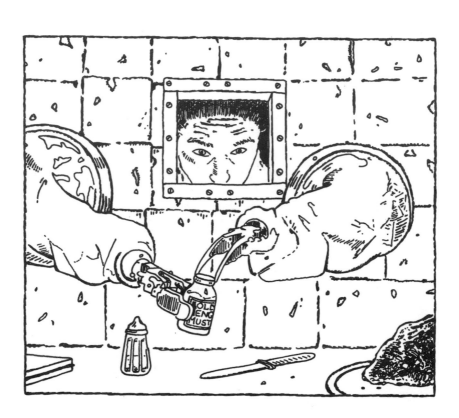

SCHOOL DAYS

I REMEMBER MY FIRST DAY AT BLACKHERST SCHOOL. NEW BOYS WERE OBLIGED TO COMPLETE THE INITIATION CEREMONY OF CYCLING TO THE NEARBY VILLAGE OF DREDGEHAMPTON...

...AND BRINGING BACK THE BLACK-
HERST ANVIL.

I HAD DECIDED TO MAKE SOME ADJUSTMENTS TO THE SCHOOL UNIFORM, BUT THIS SEEMED TO BE A SOURCE OF GRAVE CONCERN TO MY FATHER AND I REMEMBER BEING TAKEN TO SEE A DOCTOR ZEUGMANN

AFTER A FEW HOURS OF TESTS AND QUESTIONS
I WAS ALLOWED TO LEAVE AND SOON I WAS
JOINING THE OTHER LADS ON THE WAY
TO BLACKHERST HIGH.

THE TWENTY MINUTE JOURNEY TO SCHOOL
WAS NOT, HOWEVER, WITHOUT ITS PROBLEMS

GRADUALLY I BEGAN TO SETTLE
DOWN TO THE QUIET RHYTHM
OF SCHOOL LIFE

DURING THOSE FIRST WEEKS AT SCHOOL
1 BEGAN TO DEVELOP A PERSECUTION
COMPLEX

I MUST CONFESS THAT SOME OF THE
ACTIVITIES OF THE MEMBERS OF
STAFF LEFT ME FEELING SLIGHTLY
UNEASY....

THE LADS HAD WARNED ME ABOUT
MR. SNEADE, THE HEAD OF THE
MUSIC DEPARTMENT

DURING THE FIRST TERM AT SCHOOL I
RECALL THAT THE CHESS SOCIETY MADE
FREQUENT VISITS TO MY STUDY WITH
A VIEW TO MY BECOMING A MEMBER....

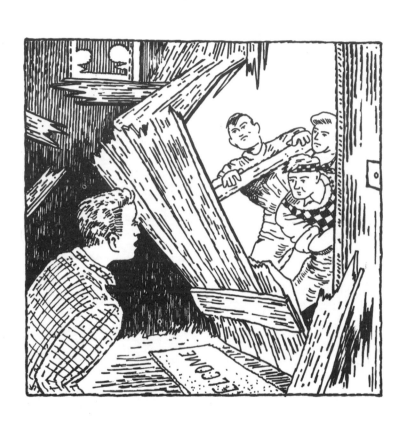

MY FRIEND RONNIE AND I WOULD
OFTEN STAY BEHIND AFTER THE
LAST LESSON ON THURSDAYS

IT WAS THEN THAT MR. CLUMBERS
TOOK IT UPON HIMSELF TO
INSTRUCT US IN THE ART OF
SHOPLIFTING

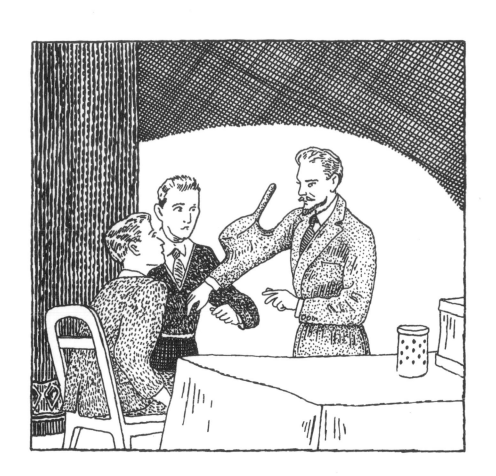

THERE WERE SOME DIFFICULT
MOMENTS AT BLACKHERST.
YOUNG RAEBURN OCCUPIED
THE STUDY BENEATH MINE
AND THERE WERE TIMES
WHEN 1 BEGAN TO SUSPECT
THAT HE WAS DELIBERATELY
TRYING TO DISTURB MY
CONCENTRATION...

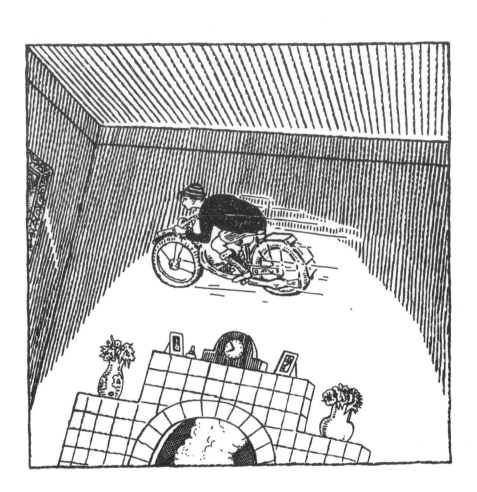

IT WAS ABOUT THIS TIME THAT I
BEGAN TO THINK SERIOUSLY ABOUT
MY FUTURE. I REMEMBER HOW I
ENTERTAINED THOUGHTS OF
TAKING UP DENTISTRY....

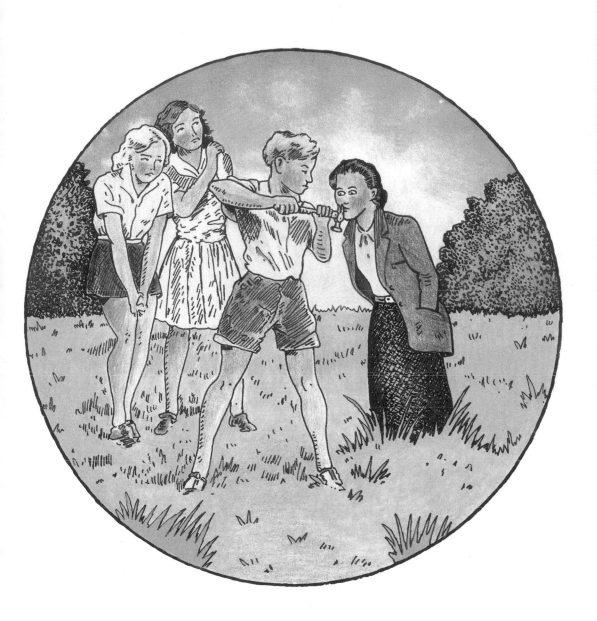

MY AMBITION OF PURSUING A CAREER
IN GARDENING WAS EQUALLY SHORT-
LIVED.....

MY SISTER JOINED ME AT SCHOOL IN
THE AUTUMN TERM. SOON AFTER
HER ARRIVAL THINGS BEGAN TO
GO SERIOUSLY WRONG. A NUMBER
OF STRANGE NEW PLANTS WERE
FOUND GROWING NEXT TO MR. HODGE'S
PRIZE CHRYSANTHEMUMS IN THE
SCHOOL GREENHOUSE. THEN THERE
WAS THE STRANGE AFFAIR OF THE
DWINDLING GEOGRAPHY STAFF....
SUSPICION FELL IMMEDIATELY UPON
MY SISTER, FOR IT WAS ASSUMED
THAT THERE MIGHT BE SOME
CONNECTION BETWEEN HER NOCTURNAL
WANDERINGS AND THE MYSTERIOUS
DISAPPEARANCE OF THE GEOGRAPHY
TUTORS....

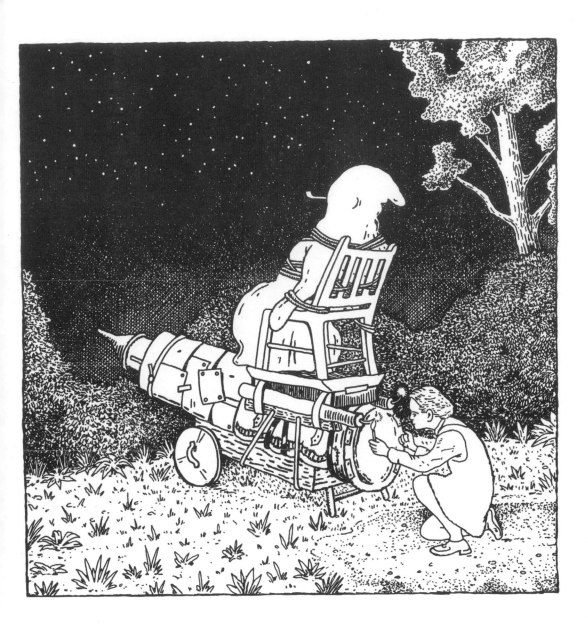

THINGS, HOWEVER, CAME TO A HEAD
ON THE EVENING OF THE 27TH
WITH THE TRIPLE DISAPPEARANCES
OF MISS MOSSOP, MISS E.A BONLEY
AND OLD MR. HOPCROET

THEN CAME THAT TERRIBLE DAY OF
THE THIRD OF APRIL, WHEN HUGE
QUANTITIES OF AVIATION FUEL
WERE DISCOVERED IN MY SISTER'S
SCHOOL SATCHEL

THE HEADMASTER HAD NO
ALTERNATIVE BUT TO ASK HER
TO LEAVE BLACKHERST

THE SCHOOL HAD ONLY JUST
RECOVERED FROM THE TRAGIC
EVENTS OF THAT TERM WHEN
THERE WERE FURTHER
DISRUPTIONS TO THE
ACADEMIC LIFE OF
BLACKHERST

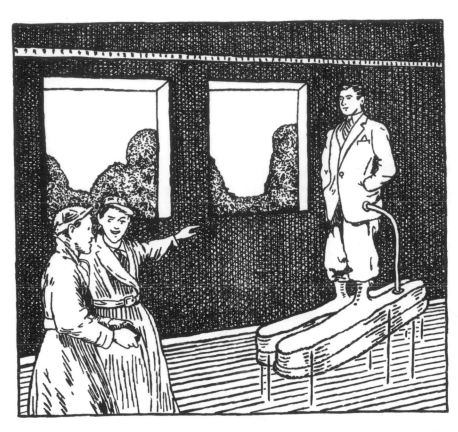

D'ARCY HAD TAKEN TO STARTLING
MEMBERS OF THE LOWER SCHOOL
WITH HIS MODIFIED LOAFERS

A NEW SET OF RULES CONCERNING
DRESS AND BEHAVIOUR WERE
POSTED UP IN THE MAIN HALL.
BOYS WERE NOW FORBIDDEN TO
WALK ALONE WITHIN AN EIGHT
MILE RADIUS OF THE GYMNASIUM

THE HEADMASTER ISSUED A
STERN WARNING ABOUT THE
RECENT OUTBREAKS OF
CUFFLINK SNATCHING IN
THE VILLAGE

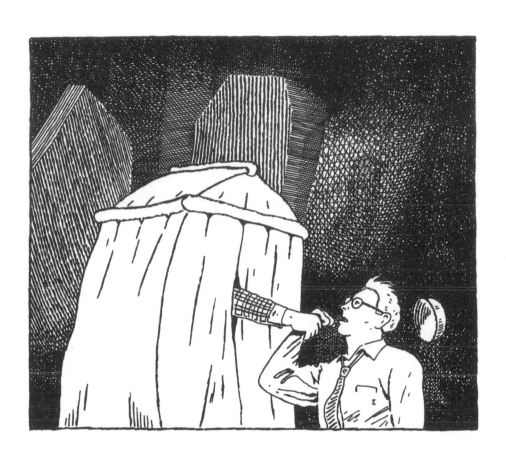

MY BEST FRIEND DURING THE GRIM DAYS OF
THE DISAPPEARANCES WAS JIMMY SCHULBE.
HIS FATHER CLAIMED TO BE THE CHIEF
SECURITY OFFICER AT THE BELGIAN
EMBASSY UP ON BURTON'S HILL. IT
WAS WELL-KNOWN, HOWEVER, THAT
SECURITY THERE HAD BEEN LAX FOR
MANY YEARS.....

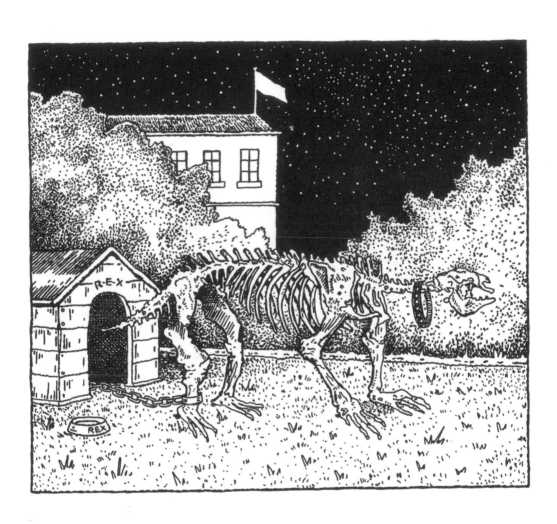

ONE OF THE HIGHLIGHTS OF
THE SECOND TERM WAS
SLIPPING OUT AT NIGHT
FOR A LATE SUPPER UP
IN BLEASEDALE THICKET

IT WAS USUALLY LEFT
TO MALCOLM GILLSOP
TO ORGANIZE THE
MIDNIGHT FEAST...

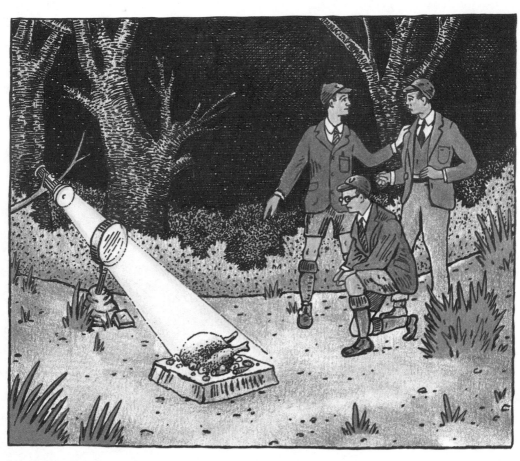

"ARE YOU SURE THIS IS GOING TO WORK?"
SNAPPED TREVOR IMPATIENTLY

THE MOONLIT EVENINGS BROUGHT
WITH THEM A WHOLE NEW SET
OF PROBLEMS...

WHICH WERE NOT EASILY
RECTIFIED

MANY OF THE LADS IN DORMITORY
'F' BEGAN TO FEEL STRANGE, NEW
SENSATIONS COURSING THROUGH
THEIR YOUNG BODIES. IT WAS NOT
TOO LONG BEFORE A COMMUNICATION
LINK WAS ESTABLISHED WITH
NEARBY SLOCOMBE VALLEY SCHOOL.
IT WAS KNOWN THAT THE GIRLS
THERE HAD DEVELOPED SOMETHING
OF A STRAIGHTFORWARD, UNINHIB-
ITED APPROACH TO SEXUAL
RELATIONSHIPS....

BUT I'M AFRAID THERE WERE
ONE OR TWO BOYS WHO FELT
UNABLE TO RESPOND TO THEIR
UNABASHED ADVANCES...

I'LL NEVER FORGET THE DAY I
MET BRENDA

OURS WAS A CURIOUS RELATIONSHIP

AFTER A BRIEF COURTSHIP,
THINGS SEEMED TO GO
SADLY WRONG....

IT WAS DURING A BRISK GAME OF
PING-PONG THAT I BEGAN TO
REALIZE THAT BRENDA'S FEELINGS
TOWARD ME HAD SOMEHOW CHANGED

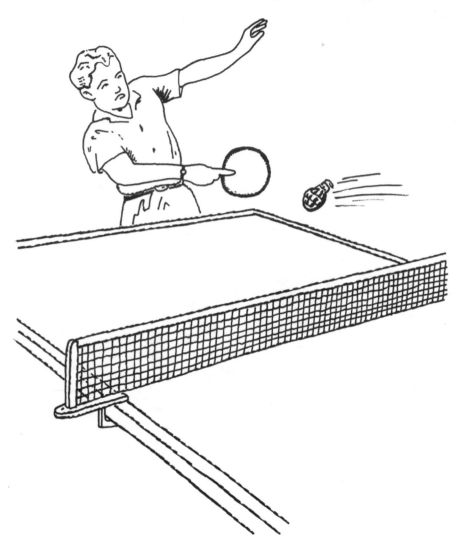

IT PROVED TO BE THE END OF
A BEAUTIFUL RELATIONSHIP

THEN THERE WAS MAVIS

I TRIED TO IMPRESS HER
WITH MY WHITTLE-WORK

AFTER A WHIRLWIND COURTSHIP
THERE FOLLOWED NIGHTS OF
FRENZIED PASSION.....

THEN THERE WAS YOUNG
STEBBJNGS

STEBBINGS WAS PASSIONATE
ABOUT JUST ONE THING....

...HIS TOOTHPICK COLLECTION

ABOUT THIS TIME I RESOLVED TO TRY
AND BANISH ALL THOUGHTS OF ILLICIT
SENSUAL PLEASURE FROM MY MIND...

IT WAS VERY DIFFICULT, UNTIL I HIT UPON
THE SOLUTION

I FORCED MYSELF TO MEMORISE EVERY
PART OF THE SCHOOL ROLLER

THE STRAIN WAS ALMOST
UNBEARABLE. AFTER EIGHT WEEKS
I TURNED, IN DESPERATION, TO
MUSIC

LATE ONE AFTERNOON, YOUNG
JUMPIN' JOHNSON REVEALED
THE SECRET OF HIS BOOGIE
WOOGIE TECHNIQUE TO ME

THERE ALWAYS SEEMED TO BE
PROBLEMS WITH LESSONS AT
BLACKHERST. THE TEACHERS
MADE VALIANT ATTEMPTS TO
COMMUNICATE WITH THE
LOWER SCHOOL....

MR BINDEN ALWAYS TRIED
HARD TO MAKE ALGEBRA
"INTERESTING"....

THE PUPILS WHO FAILED TO RESPOND TO THE NEW TEACHING METHODS WERE SENT UP TO MR. THOMPSON'S STUDY

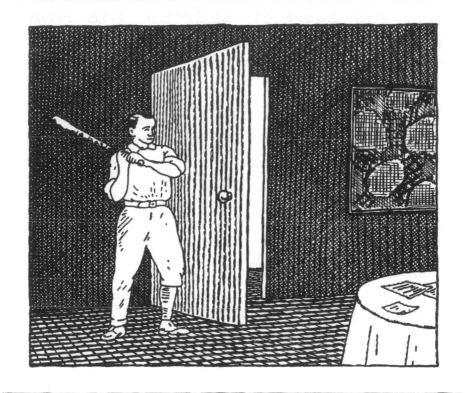

MR. THOMPSON WAS A SKILLED EXPONENT OF THE ART OF PERSUADING MISCREANTS TO SEE THE ERROR OF THEIR WAYS

ALL TOO SOON, IT SEEMED, THE FINAL
EXAMINATIONS WERE UPON US

FATHER'S REACTION TO MY EXAMINATION
RESULTS WAS PREDICTABLE ENOUGH

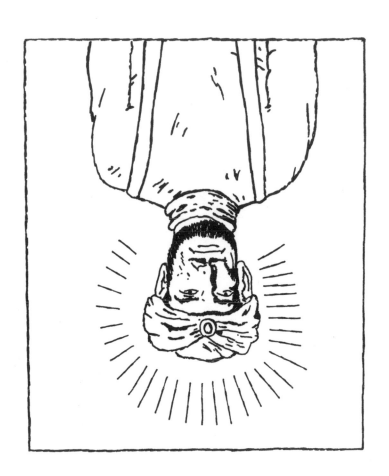

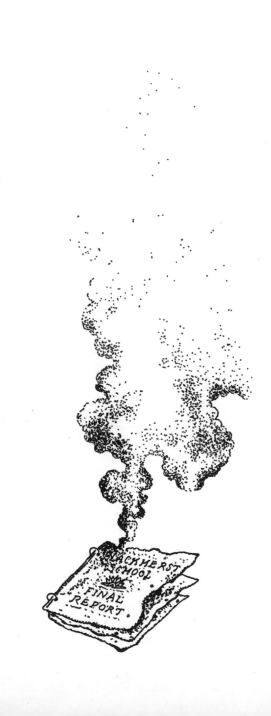

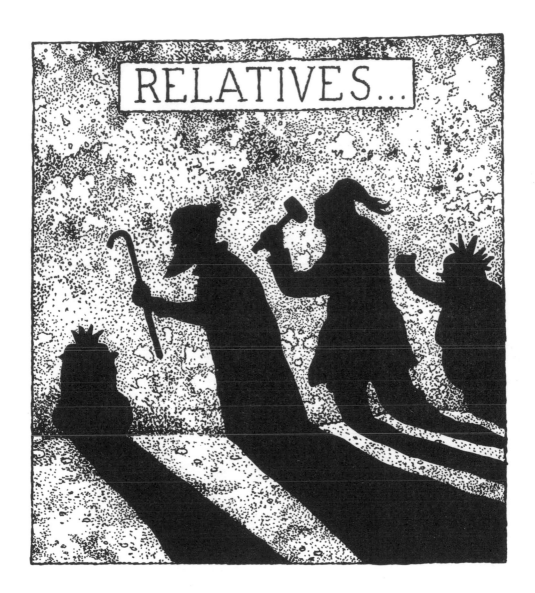

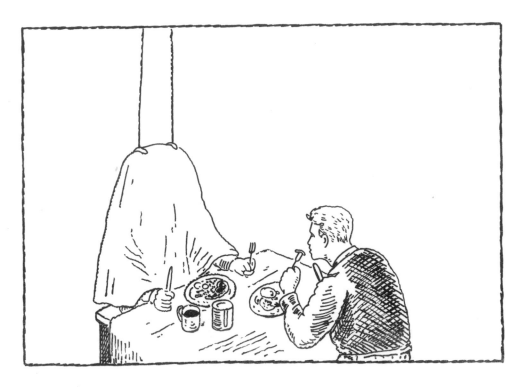

UNCLE EDWIN OFTEN STAYED WITH US FOR
THE LONG WINTER MONTHS. IT WAS
SOMETHING THE FAMILY NEVER MENTIONED.
MY SISTER AND I WERE FORBIDDEN TO
SPEAK TO HIM OR EVEN ACKNOWLEDGE
HIS PRESENCE AT MEALTIMES. THE
SUBJECT OF UNCLE EDWIN WAS STRICTLY
TABOO....

OUR COUSIN SYDNEY POSSESSED
AN INSATIABLE APPETITE. HE
WAS CONSTANTLY SLIPPING
OUT THE BACK OF HIS NEW
BUNGALOW IN SEARCH OF
SNACKS BETWEEN MEALS

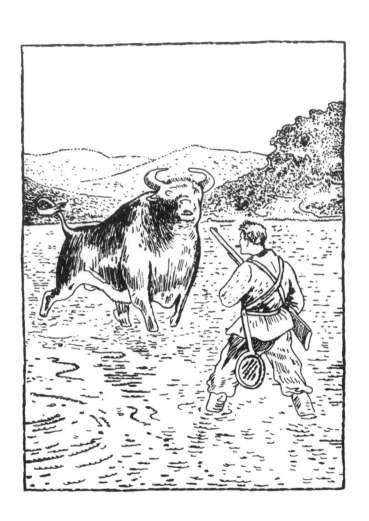

TOTALLY UNLIKE OUR GREAT UNCLE DON, WHO DISPLAYED SCANT INTEREST IN HAUTE CUISINE...

HE WAS A FIRM BELIEVER
IN CONVENIENCE FOODS

THEN THERE WAS MY GREAT UNCLE
SIGMUND WHO RAN AN UNSUCCESSFUL
BARBER SHOP IN DORTMUND......

HIS CLIENTS WERE EASILY IDENTIFIED
EVEN IN THE THICKEST CROWDS....

FROM TIME TO TIME, UNCLE WILF FROM
CLEETHORPES WOULD PAY US ONE OF HIS
FAMOUS "UNEXPECTED VISITS"....

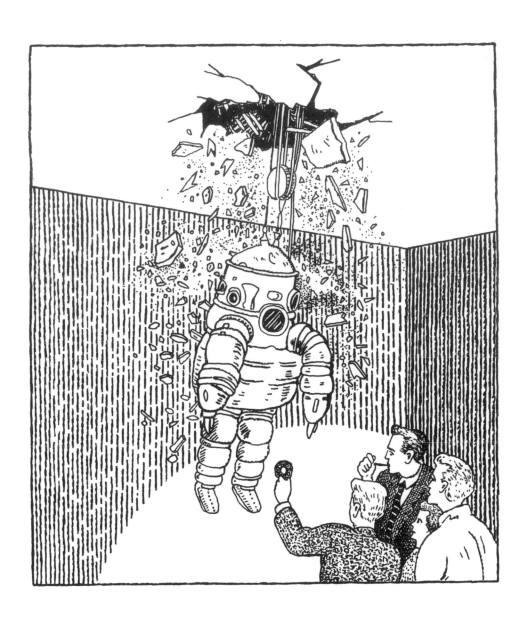

I REMEMBER THAT EVERY 19TH OF JUNE WE
WERE TAKEN ON A LONG TRAIN RIDE TO THE
OUTSKIRTS OF LOWER HECKMONDWIKE.
IT WAS HERE THAT MR. GOMERSALL, AN
OLD FRIEND OF THE FAMILY, LIVED.
WHEN WE ARRIVED WE WERE USHERED
INTO THE SCULLERY, WHERE WE WAITED
UNTIL 4.30 P.M, WHEN A GONG WOULD
ANNOUNCE THE HIGHLIGHT OF THE
AFTERNOON.

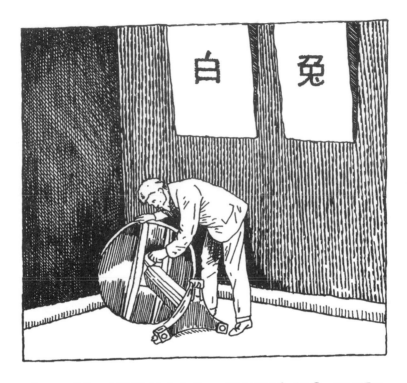

MR. GOMERSALL TOOK US INTO
THE BACK ROOM AND SHOWED
US WHERE HE KEPT THE STILTON

MY SISTER AND I WERE ALLOWED A BRIEF EXAMINATION OF THE TABLE BEFORE BEING USHERED BACK INTO THE SCULLERY

THE TRAIN JOURNEY HOME WAS ALWAYS COMPLETED IN UTTER SILENCE

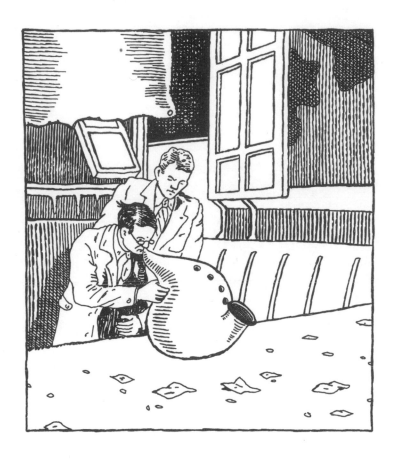

... ALL THE WAY DOWN TO WILTSHIRE
WHERE I WAS SENT TO ASSIST OUR
UNCLE EDWARD DURING THE
CRITICAL FINAL WEEK OF TESTS
ON HIS NOSE-FLUTE

THEN THERE WERE THE EXHAUSTING
COACH TRIPS DOWN THE COAST TO
REDCAR TO STAY WITH AUNTIE EDNA
AND UNCLE DEREK

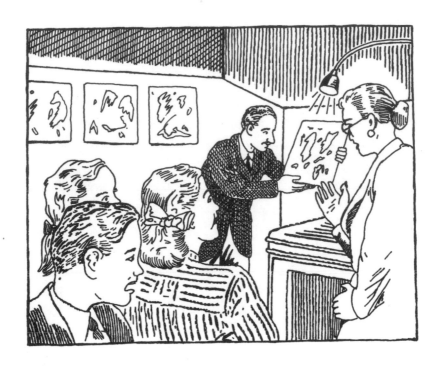

OUR WEEKENDS INVARIABLY BEGAN
WITH A THREE HOUR SEMINAR ON
UNCLE DEREK'S PAINTING...

DINNER WAS SERVED AT
AROUND 9.36

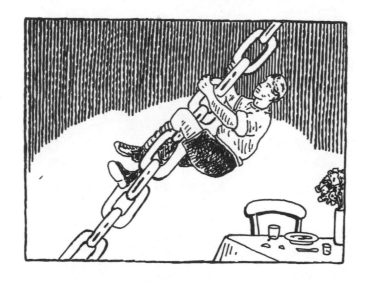

AFTER DINNER, COUSIN
GERALD WORKED OUT ON
THE CHAIN

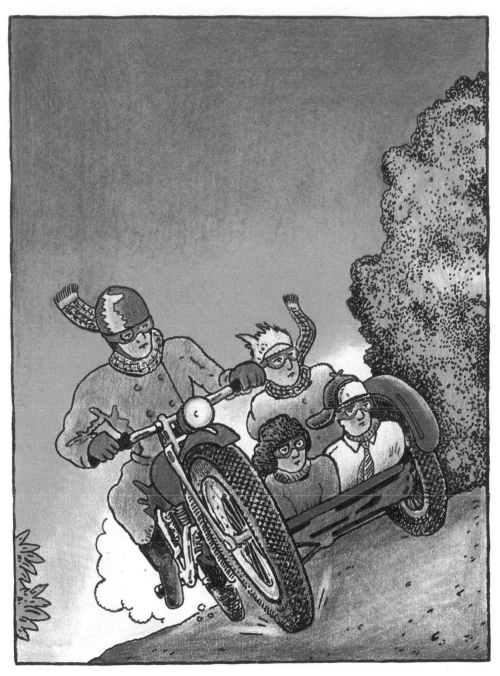

ON SATURDAY EVENING, UNCLE DEREK
TOOK EVERYONE OUT TO THE LOCAL
CINEMA — THE THRIDMOUTH RIALTO...

IT WAS HERE THAT I HAD
MY FIRST EXPERIENCE OF SOME
OF THE CLASSIC FILMS OF WORLD
CINEMA

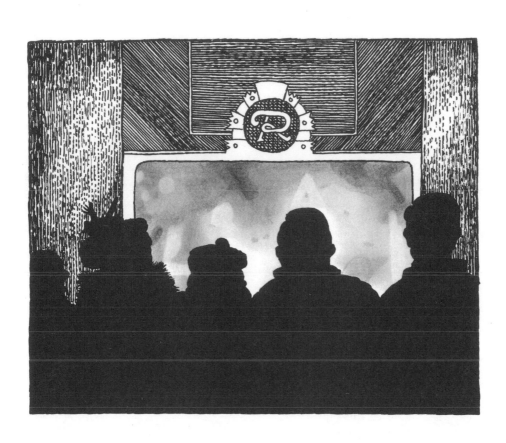

ALL TOO SOON IT SEEMED THOSE
WEEKENDS HAD FLASHED BY, AND
SO GERALD AND I WOULD LOCK
OURSELVES IN HIS WARDROBE
FOR ONE LAST GAME OF LUDO

THE DEPARTURE

MY SCHOOLDAYS WERE OVER.
MY SISTER HAD GONE OFF TO
WORK IN A MUNITIONS FACTORY
IN NORTHAMPTON. I SENSED IT
WAS TIME I TOO SOUGHT SOME
FORM OF EMPLOYMENT.

I PEERED EAGERLY AT THE
LIST OF SITUATIONS VACANT
IN "THE HUNSLET DAILY
BUGLE" AND BEGAN TO
COMPOSE A LETTER OF
APPLICATION

I WAS TAKEN INTO THE EMPLOYMENT
OF THRIMMIDGE, THRIMMIDGE AND
BLEASBY AS A JUNIOR CLERK

"...AND YOU'LL BE SLEEPING HERE"
INTONED MR THRIMMIDGE GRAVELY

I BECAME INCREASINGLY RESTLESS.
I WANDERED ROUND MY ROOM
LATE AT NIGHT FEELING MORE
AND MORE DEPRESSED...

FINALLY THE DAY CAME WHEN I
REALIZED IT WAS TIME FOR ME
TO LEAVE HOME

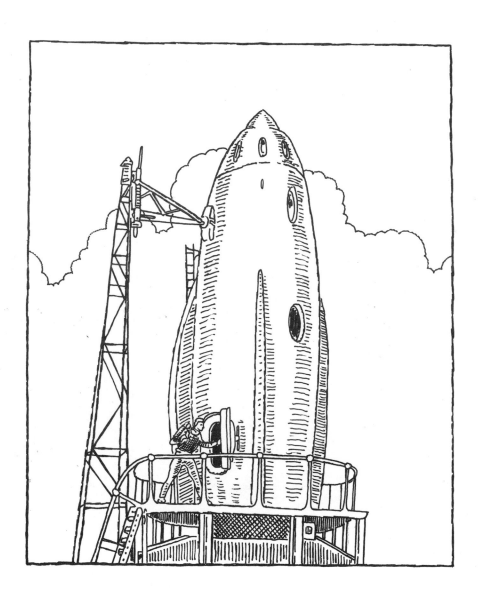

BIBLIOGRAPHY

This bibliography has been culled from the archives of the British Museum Reading Room, London, and the Library, University of Texas at Austin.

ALICE MARY BAXTER
Adventure Comes to Brackendene
ALLAN MUIR BAXTER
The Distribution of Load along Nuts
The Fatigue of Bolts and Studs
ANDREW BAXTER Thoughts on Dreaming
An Enquiry into the Nature of the Human Soul
Matho; sive cosmoth eoria puerilis
ANNE BAXTER Intermission: a true story
ANNETTE KAR BAXTER Henry Miller, expatriate
ARCHIBALD BAXTER We Will Not Cease
SIR ARTHUR BEVERLEY BAXTER
The Blower of Bubbles
First Nights and Footlights
Strange Street
BATSELL BARRETT BAXTER Speaking for The Master
BERNICE BAXTER Group Experience: The Democratic Way
Growth in Human Relations
BERTRAM BAXTER Stone Blocks and Iron Rails
BRIAN NEWLAND BAXTER Teach Yourself Naval Architecture
BRUCE LEE BAXTER An Elliptic Function Solution of the Nonlinear Differential Equation of Motion in Synchronous Machines
C.E. BAXTER Talofa
CHARLES BAXTER Chameleon
CHARLES HOMER BAXTER
Examination and Valuation of Mineral Property by Baxter and Parks
CHARLES NEWCOMB BAXTER Boston Athenaeum
CHERRIE FULLER BAXTER A Study of Administration of Old Age Assistance in Douglas County
CRAIG BAXTER District Voting Trends in India. A Research Tool
The Jana Sangh
Servants of the Sword
DAVID ROBERT BAXTER
Superimposed Load Firearms 1360-1860 (South China Morning Post, Hong Kong)
DOREEN BAXTER Dreamland Frolics
DOW VAWTER BAXTER Occurrence of Fungi in the Major Forest Types of Alaska
Some Resupinate Polypores from the Region of the Great Lakes
Importance of Fungi and Defects in

Handling Airplane Spruce
DUDLEY BAXTER Cardinal Pole
The Holy Rood
E.B. BAXTER The Essentials of Materia Media and Therapeutics
EDNA DOROTHY BAXTER
An Approach to Guidance
EDWARD HENRY BAXTER National Flags With Aircraft Markings, Calendar of Days for Hoisting National Flags and Colour Keys for Ready Identification
ELIZABETH BAXTER The Healer
Sensitiveness and Its Cure
ERIC BAXTER The Study Book of Coal
EVELYN VIDA BAXTER A Vertebrate Fauna of Forth
Some Scottish Breeding Duck
The Birds of Scotland
Scottish Women's Rural Institute Cookery Book
FRANK C. BAXTER Days in the Painted Desert and the San Fransisco Mountains
FRED BAXTER Snake for Supper
GARRETT BAXTER Baxter's Economics
Great Battles
Individualism
Powers
GEORGE BAXTER Spiritualism – The Hidden Peril, by an ex-medium (G. Baxter)
GEORGE BAXTER The Ballads of Mary Magdalene and Other Poems
The Pictorial Album; or Cabinet of Paintings
Dawson's Book Shop, Los Angeles
GEORGE OWEN BAXTER Call of the Blood
Free Range Lanning
King Charlie
The Whispering Outlaw
GEORGE ROBERT WYTHEN BAXTER
Humour and Pathos
The Book of the Bastiles, or The History of the Working of the New Poor Law
Don Juan Junior: A poem by Byron's Ghost
SIR GEORGE WASHINGTON BAXTER
Elk Hunting in Sweden
GILLIAN JOSE CHARLOTTE BAXTER
The Perfect Horse
Horses in the Glen
Tan and Tarmac
GLAISTER BAXTER The Agricultural Problems of Panama
GLEN BAXTER The Falls Tracer
The Khaki
Cranireons ov Botya
The Works
The Impending Gleam
Atlas

GLEN WILLIAM BAXTER Index to the Imperial Register of Tz'u Prosody, Ch'in-ting Tz'u-p'u
GORDON BAXTER Vietnam: Search and Destroy
G.P. BAXTER Researches Upon the Atomic Weights of Cadmium, Manganese, Bromine, Lead, Arsenic, Iodine, Silver, Chromium and Phosphorus
GREGORY PAUL BAXTER Theodore William Richards
HAMILTON A. BAXTER Blood Histamine Levels in Swine Following Total Body X-Radiation and a Flash Burn
Influence of Rapid Warming on Frostbite in Experimental Animals
HARRIET WARNER BAXTER
Poemscapes
HARRY BAXTER Oboe Reed Technique
HAZEL BAXTER Doctor in Doubt
Helicopter Nurse
HENRY FOSTER BAXTER On Organic Polarity
HENRY WRIGHT BAXTER A.C. Wear Tests on Low Voltage A.C. Contactor Tests
Calculated Curves of Inductive Energy at the Start of Arcing in Fuels
GEORGE YOUNG BAXTER JNR & HUBERT EUGENE BAXTER
Descriptive Geometry
HUGO F. BAXTER Soi-disant. Poems with original drawings
IAN FRANCIS GEORGE BAXTER
The Law of Banking and the Canadian Bank Act
Essays on Private Law: Foreign Law and Foreign Judgements
IVY BAXTER The Arts of an Island
J. BAXTER A Toile for Two-legged Foxes
J. BAXTER Statistics, Medical and Anthropological of the Provost-Marshal-General's Bureau derived from records of the examination for military service in the armies of the United States during the late War of the Rebellion of over a million recruits, drafted men, substitutes and enrolled men. Compiled under direction of the Secretary of War, Washington 1875
JAMES BAXTER Culture of Harmony & Structure of Composition
Fires of No Return
JAMES ALBERT BAXTER Accounting in a Building Stone Quarrying & Fabricating Business
JAMES CLEVELAND BAXTER Mediated Generalization as a Function of Semantic Differential Performance
JAMES HOUSTON BAXTER What to